Petrolia Ontario in Colour Photos, Saving Our History One Photo at a Time

Photography
by Barbara Raue
2016

Series Name:
Cruising Ontario

Book 137: Petrolia

Cover photo: Petrolia Line, Page 23

Series Name: Cruising Ontario
Saving Our History One Photo at a Time
in colour photos

Books Available in Alphabetical Order:
Aberfoyle, Acton, Alton, Ancaster, Arthur, Aylmer, Ayr, Bloomingdale, Brantford, Burlington, Caledon, Caledonia, Cambridge, Clifford, Conestogo, Delhi, Dorchester to Aylmer, Drayton, Drumbo, Dundas, Eden Mills, Elmira, Elora, Fergus, Guelph, Hagersville, Hamilton, Hanover, Harriston, Hespeler, Jarvis, Kitchener, Linwood, Listowel, London, Lucknow, Mono, Mount Forest, Neustadt, New Hamburg, Niagara-on-the-Lake, Oakville, Orangeville, Orillia, Owen Sound, Palmerston, Peterborough, Port Elgin, Preston, Rockwood, Seaforth, Sheffield, Shelburne, Simcoe, Southampton, St. Jacobs, St. Thomas, Stoney Creek, Stratford, Tillsonburg, Waterdown, Waterford, Waterloo, Wellesley, Wingham

Book 114-116: Waterloo
Book 117-119: Windsor
Book 120-121: Amherstburg
Book 122: Essex
Book 123-124: Kingsville
Book 125-127: Woodstock
Book 128: Thamesford
Book 129-132: St. Mary's
Book 133-136: Sarnia
Book 137: Petrolia

Other Books by Barbara Raue

Coins of Gold

Arrows, Indians and Love

The Life and Times of Barbara
Volume 1: Inventions That Have Enhanced My Life
Volume 2: Entertainment That I Have Enjoyed
Volume 3: East Coast Trips
Volume 4: Olympics Have Always Intrigued Me
Volume 5: Wonders of the World
Volume 6: Caribbean Cruises We Have Enjoyed
Volume 7: Animals
Volume 8: Storms and Other Major Disasters in My Lifetime
Volume 9: Wars, Terrorist Attacks and Major Disasters

The Cromwell Family Book

Laura Secord Discovered

Daddy Where Are You?

Visit Barbara's website to view all of her books
http://barbararaue.ca

Petrolia is a town in Ontario twenty minutes from Sarnia, and fifty minutes from London.

Following the discovery of oil at Oil Springs in 1857, prospectors extended their search to the entire township of Enniskillen. At the site of Petrolia, which contained two small settlements with post offices named Durance and Ennis, a well was brought into production in 1860. The following year a small refinery was opened and the Durance Post Office renamed "Petrolea". In 1865-66, the drilling of the King well established Petrolia as the major oil producing center in Canada and its population soared from about three hundred to two thousand three hundred.

Oil men from Petrolia travelled to the far reaches of the world (Gobi Desert, Arctic, Iran, Indonesia, the United States, Australia, Russia, and over eighty other countries) teaching others how to find and extract crude oil. Some oil fields in the area are still operational to this day.

Oil enticed people to come here, but Petrolia was created, nurtured, and sustained by hardworking visionaries, shopkeepers, builders, drillers, laborers, and leaders.

Table of Contents

Warren Avenue	Page 6
Ella Street	Page 11
Emma Street	Page 12
Emmaline Street	Page 17
Greenfield Street	Page 18
Petrolia Line	Page 20
Queen Street	Page 34
King Street	Page 36
Architectural Terms	Page 61
Building Styles	Page 65

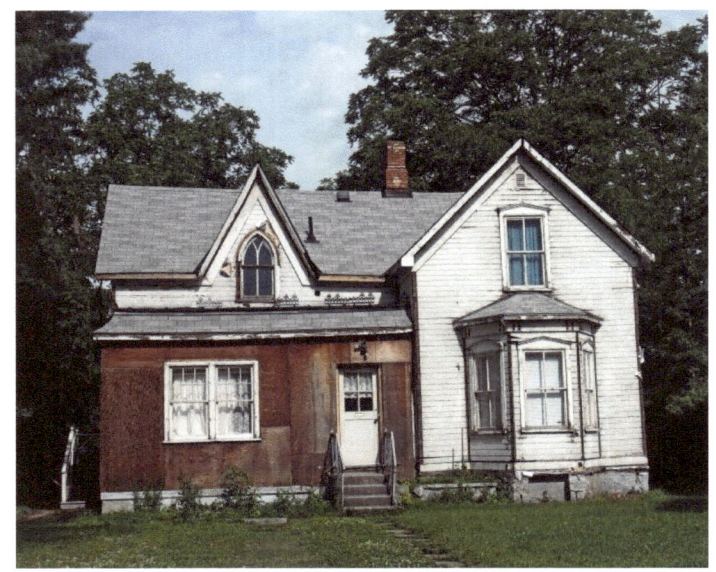

Warren Avenue – Gothic Revival – bay window

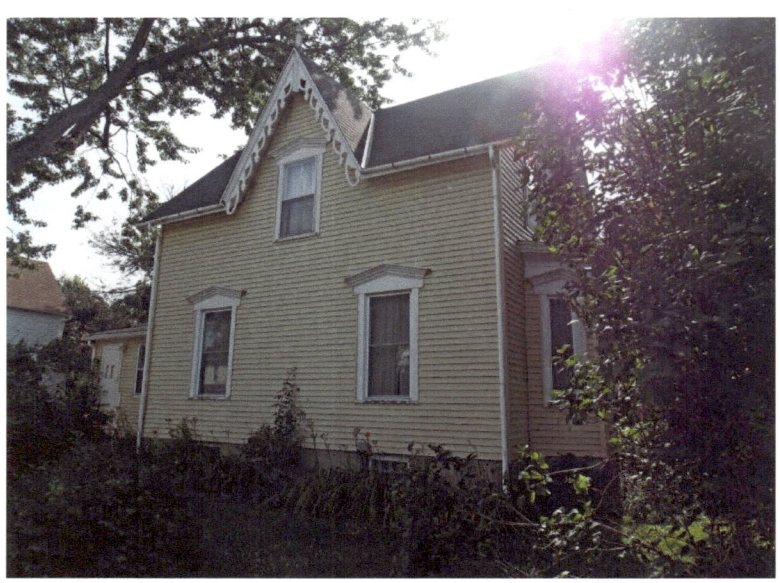

Warren Avenue – Gothic Revival – verge board trim on gable

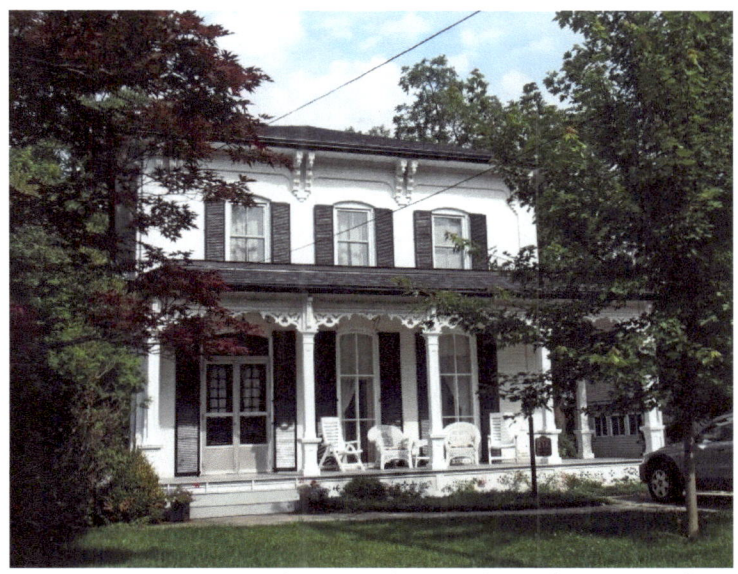

416 Warren Avenue – Italianate, hipped roof, cornice brackets, bric-a-brac on verandah

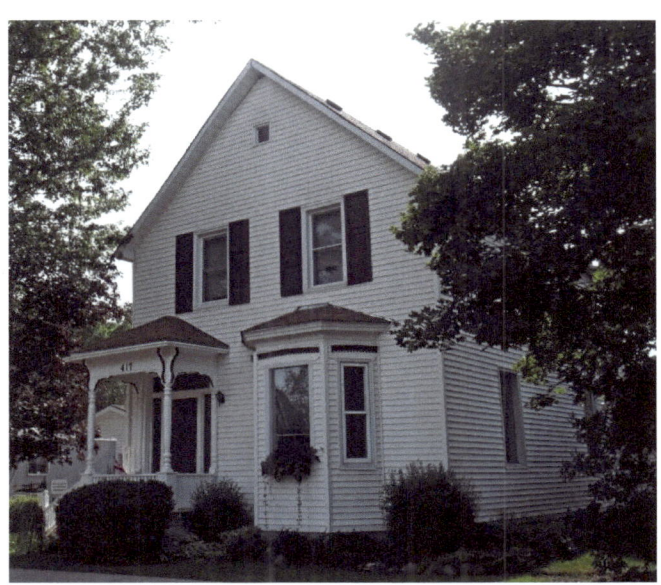

417 Warren Avenue – Gothic, bay window

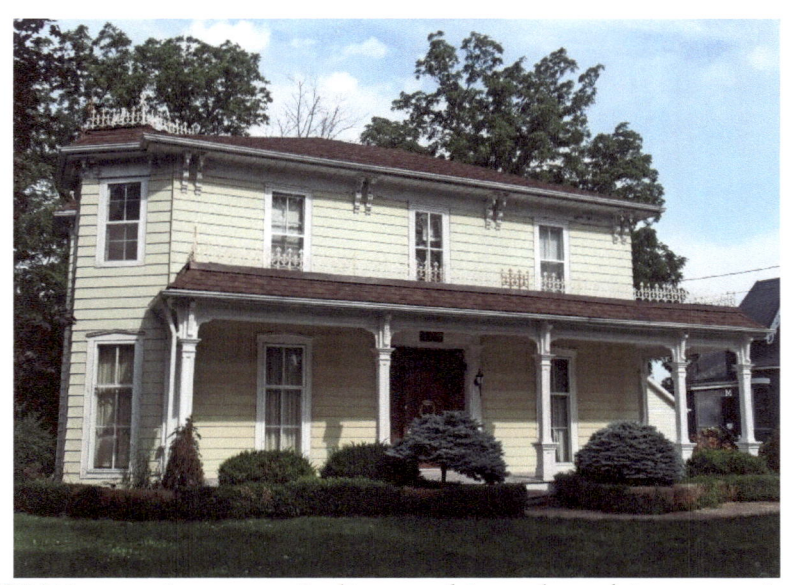

420 Warren Avenue – Italianate, hipped roof, iron cresting around 'widow's walk' and above verandah, paired cornice brackets

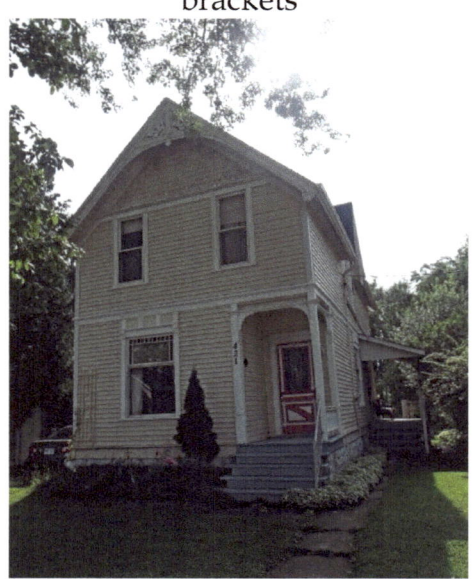

421 Warren Avenue – Gothic Revival – stenciling and trim on top of gable

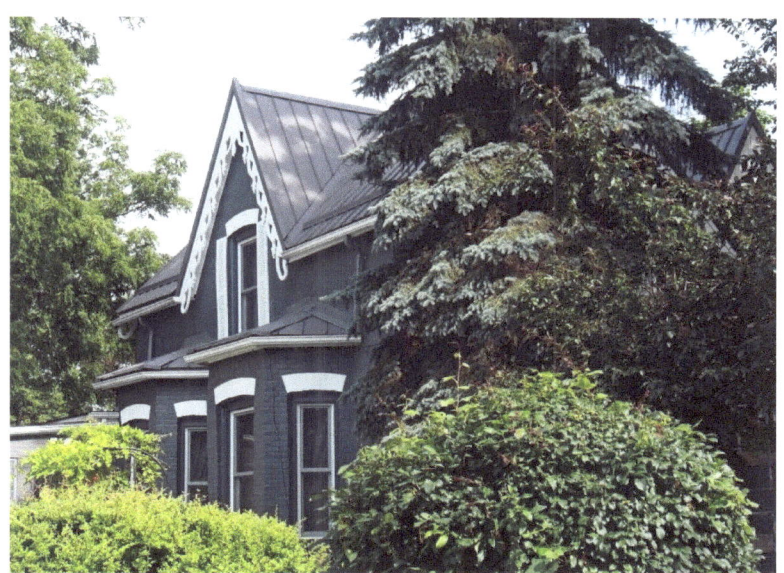

Warren Avenue – Gothic Revival – verge board trim on gable, bay windows

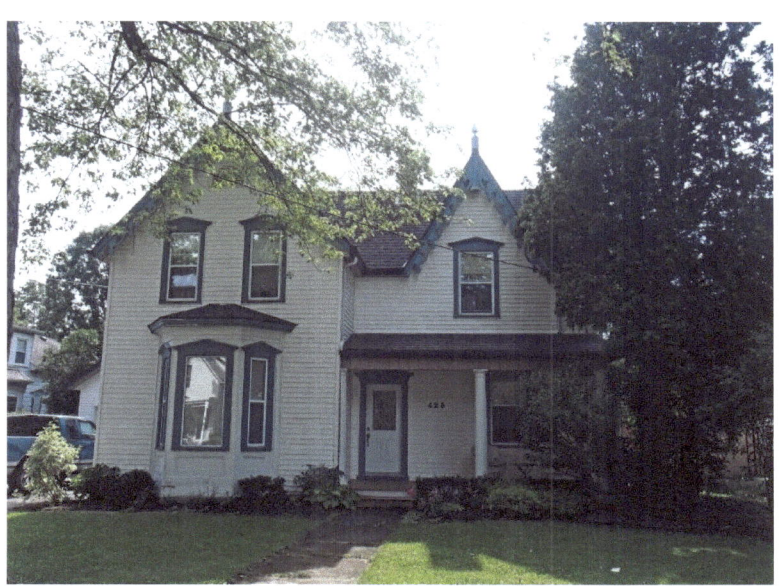

423 Warren Avenue – Gothic Revival, verge board trim and finial on gable, bay window

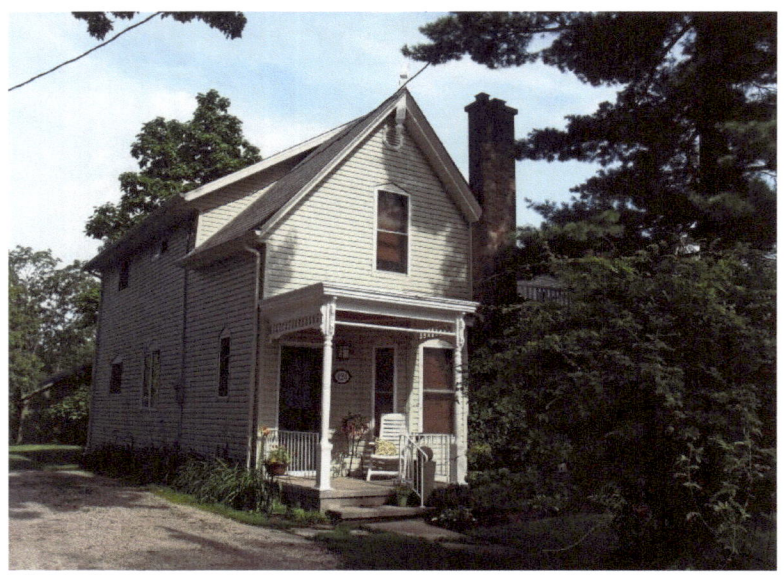

424 Warren Avenue – vernacular style, finial on gable, spindles on porch

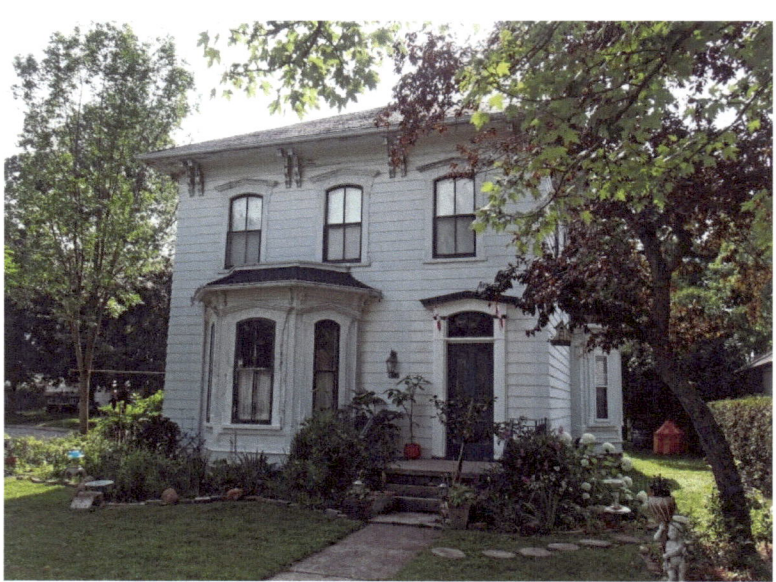

Warren Avenue – Italianate, hipped roof, paired cornice brackets, bay window

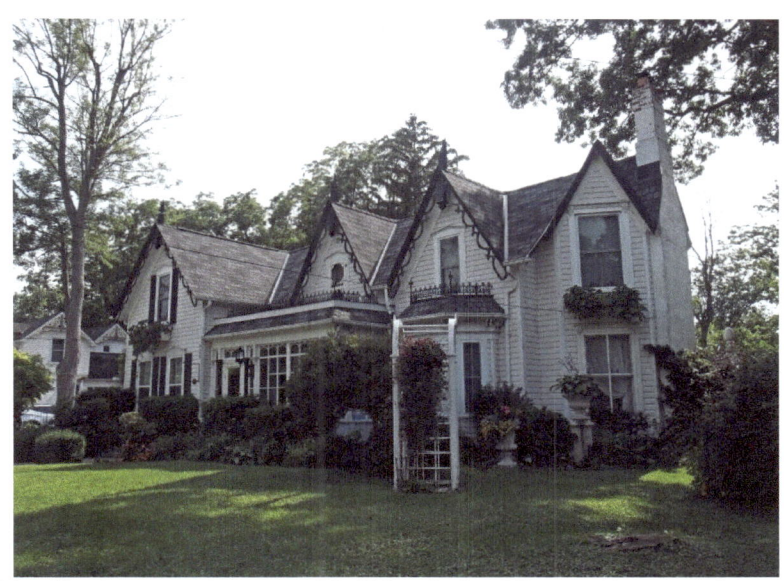

429 Ella Street – Lancey Hall built by Henry Warren Lancey c. 1876 – Gothic Revival – verge board trim and finials on gables, iron cresting above bay window and enclosed front porch

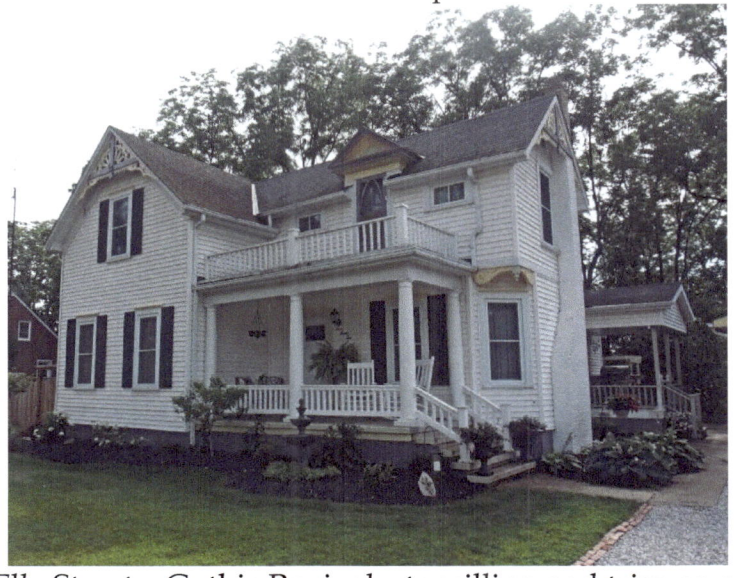

431 Ella Street – Gothic Revival, stencilling and trim on gable, second floor balcony

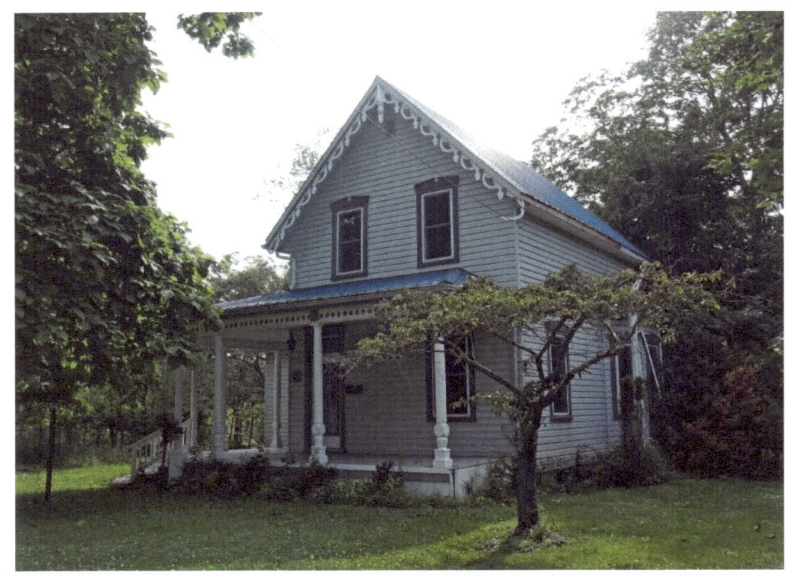

Ella Street – Gothic Revival, verge board trim and finial on gable

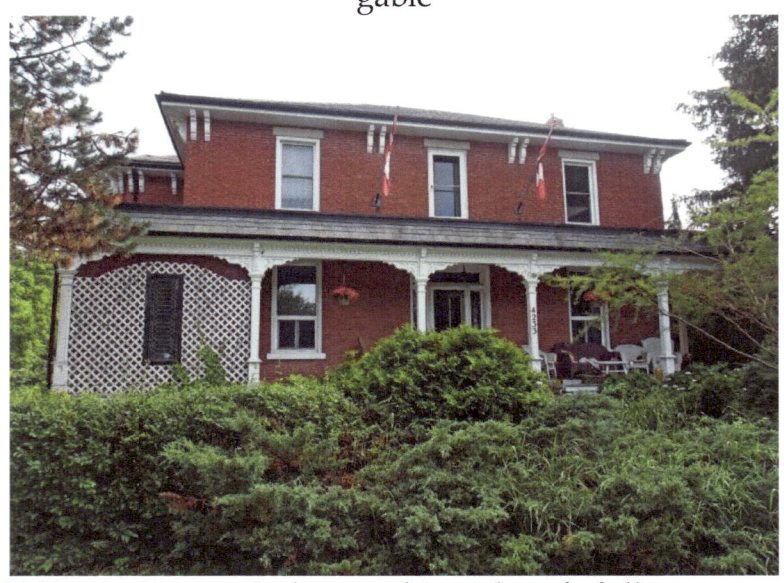

4233 Emma Street – Italianate, hipped roof, full two storeys, paired cornice brackets, bric-a-brac and dentil moulding on verandah

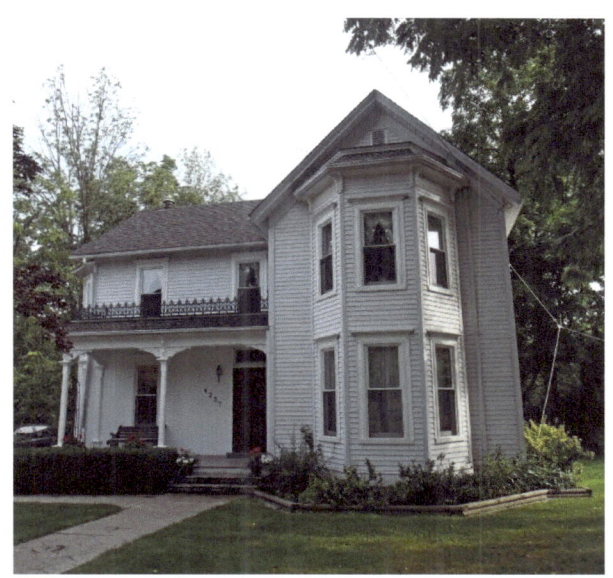

4237 Emma Street – Gothic Revival, two-storey bay window, iron cresting above verandah

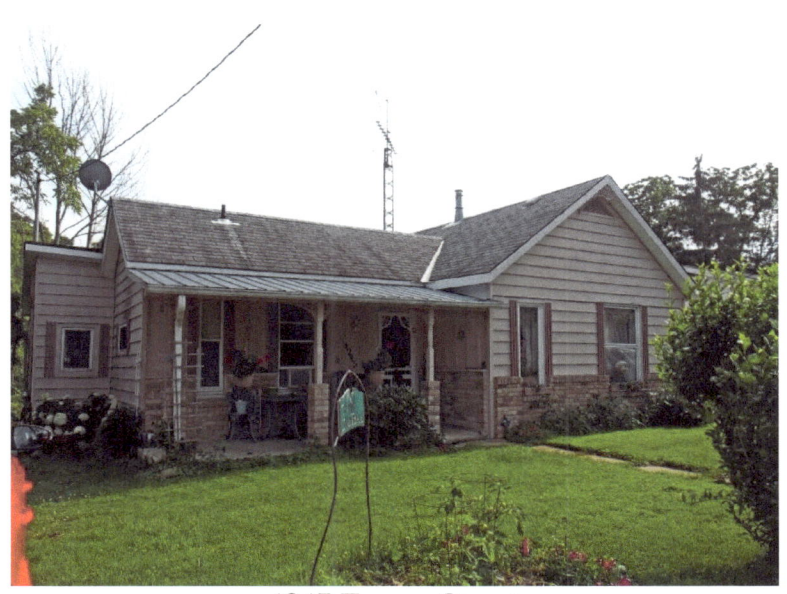

4245 Emma Street

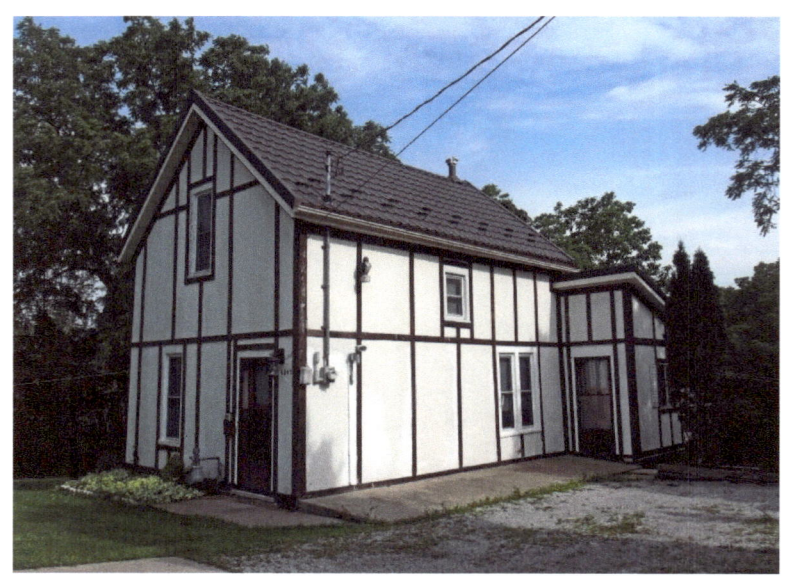

4247 Emma Street – Tudor-like appearance - Gothic

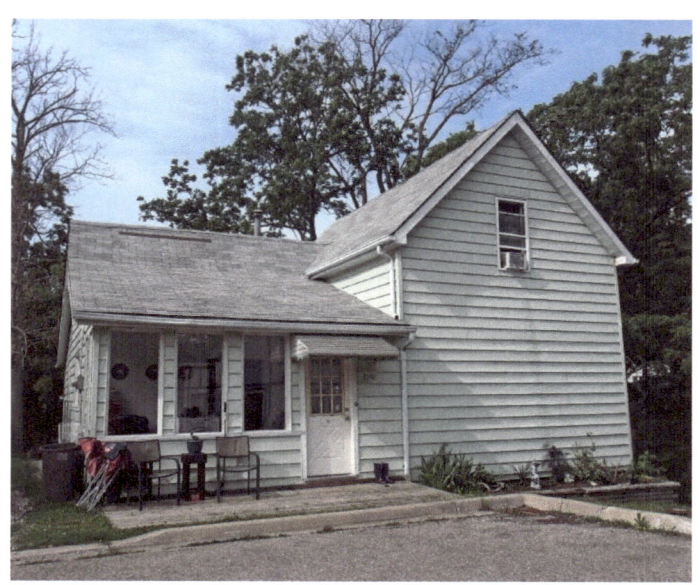

4246 Emma Street - vernacular

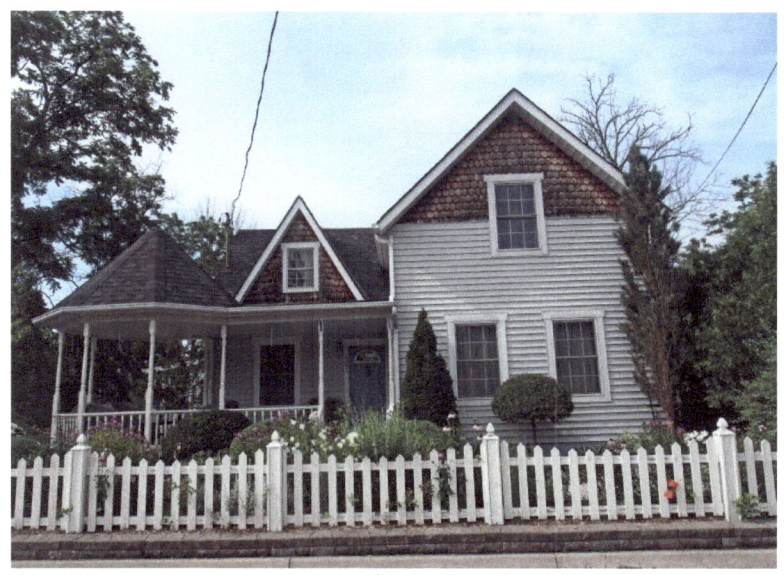

4244 Emma Street – Gothic, circular verandah with cone-shaped roof

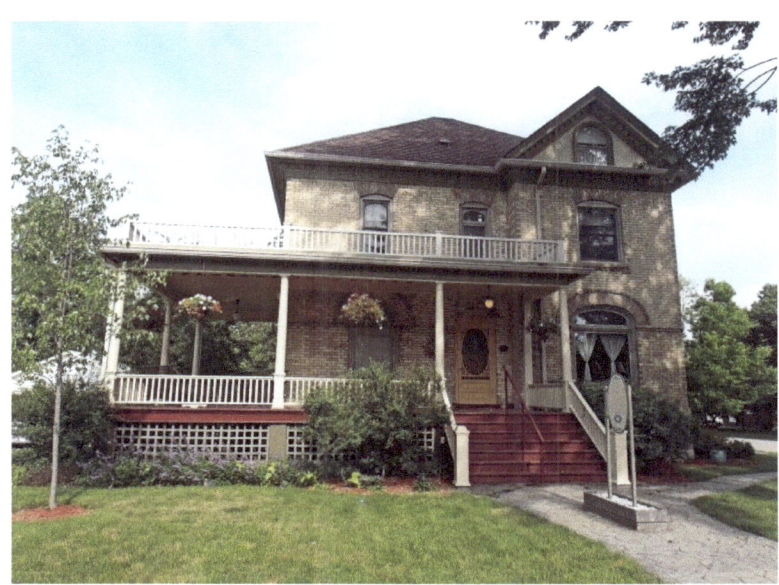

440 – Heritage Building – Italianate, hipped roof, two-storey wraparound verandah, 2½-storey frontispiece

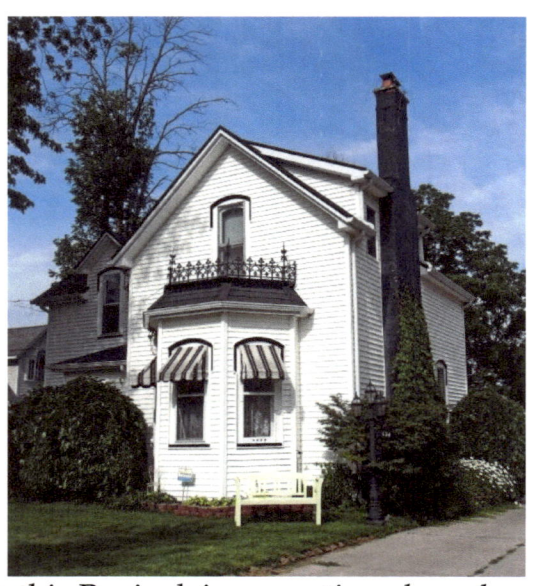

#436 – Gothic Revival, iron cresting above bay window

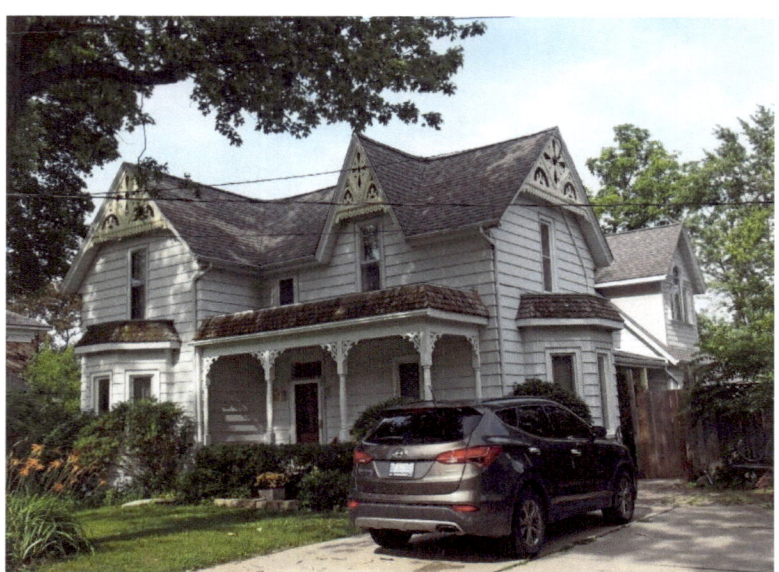

#434 – Gothic Revival, bargeboard trim on gables, bric-a-brac on verandah, bay windows

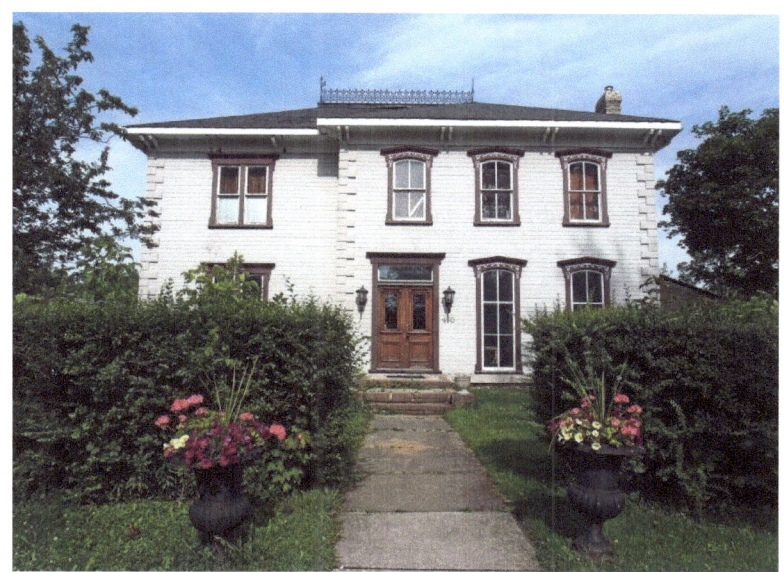

#430 – Italianate, hipped roof, corner quoins, iron cresting on roof (widow's walk), paired cornice brackets

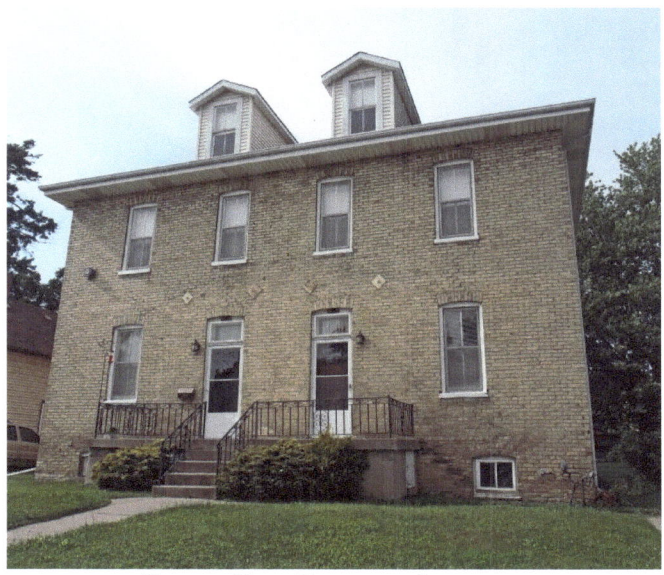

Emmaline Street – dormers

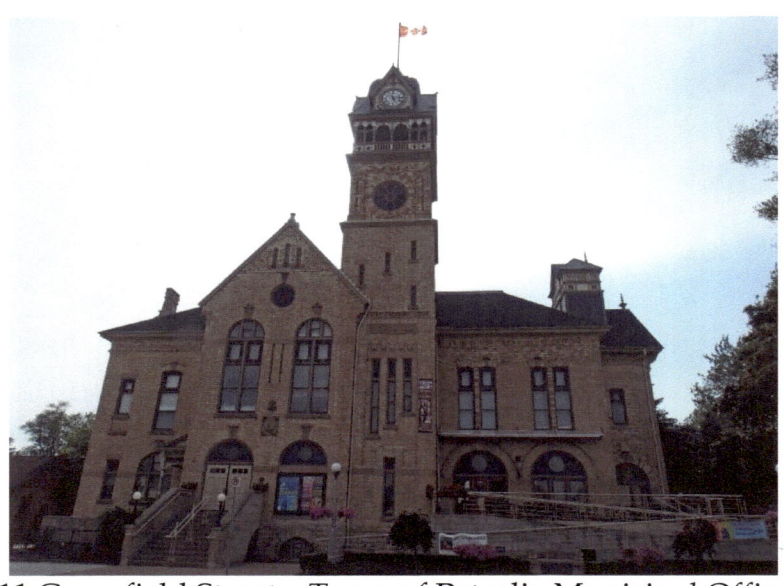

411 Greenfield Street – Town of Petrolia Municipal Offices
Queen Anne style, rose windows

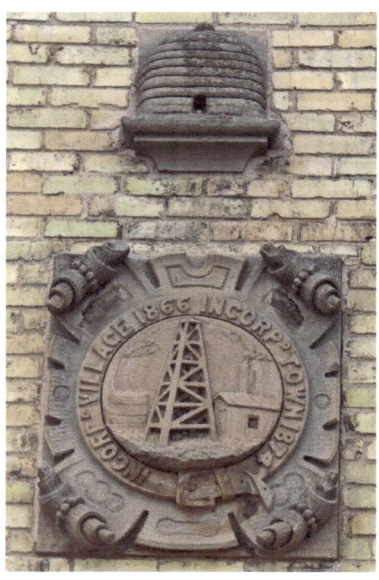
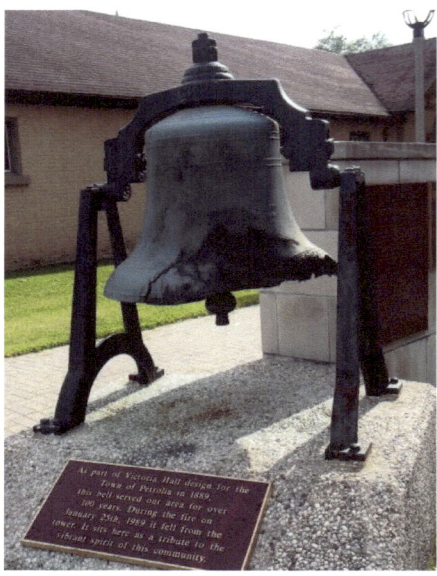

When Victoria Hall was built in 1889, Petrolia, in the midst of an oil boom, was one of the wealthiest towns in Canada. The opulent town hall reflects this stage in the town's growth. The first floor housed municipal offices, court room, fire department and armoury. The entire second floor was an opera house that could seat one thousand people.

During the 1900s, the town's oil industry declined. By the late 1950s, the opera house fell into disrepair through disuse. In the early 1970s, a teacher and his students wanted to use it and decided to clean it up. This sparked local citizens to raise funds to restore the building and make it a cultural and community center.

As part of the Victoria Hall design, the bell (pictured above) served the town for one hundred years. During the fire on January 29, 1989, the bell fell from the tower. It sits as a tribute to the vibrant spirit of the community. The building was restored following the fire and re-opened in 1992.

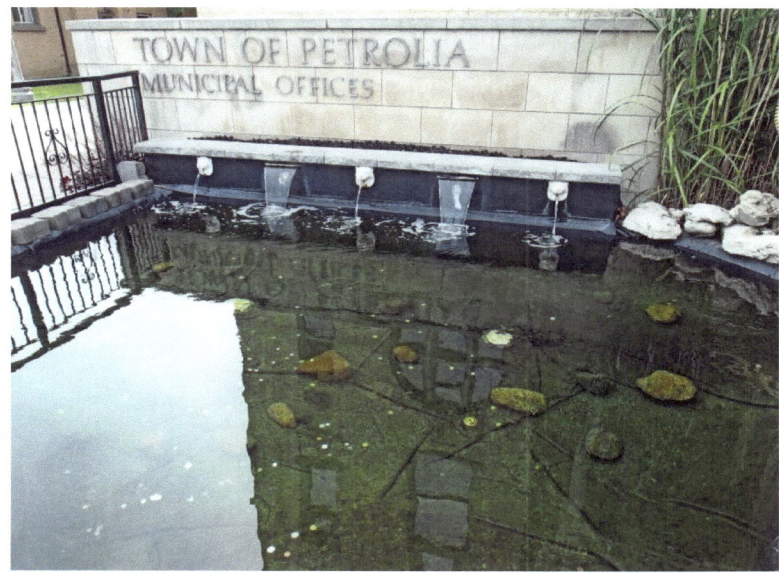

Rotary Club of Petrolia celebrated fifty years of service (1955-2005) by donating this fountain

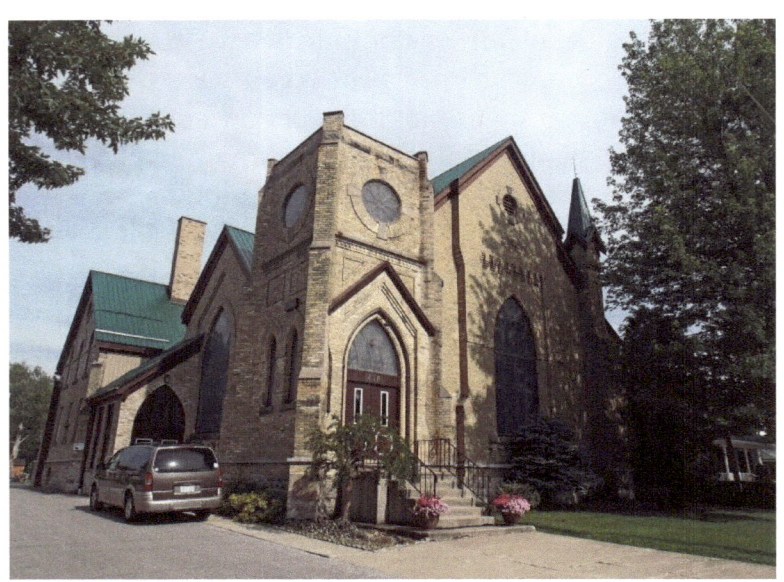

Greenfield Street – First Baptist Church erected 1896
– rose windows, buttresses, lancet windows

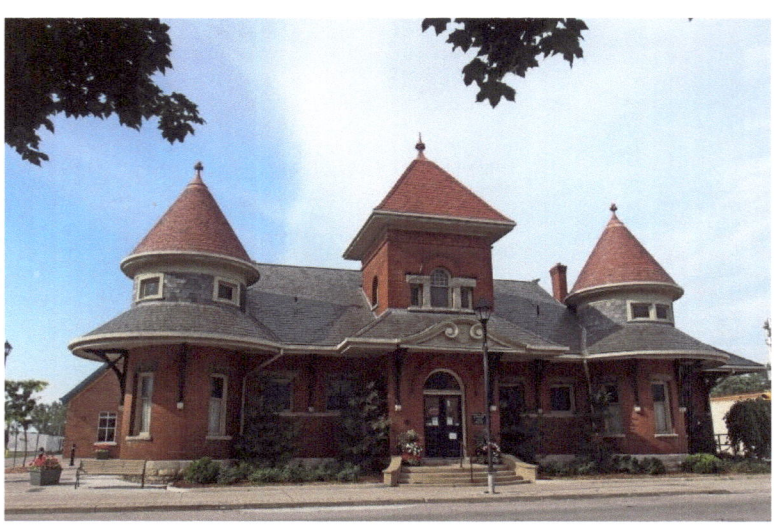

4200 Petrolia Line – The original Grand Trunk Railway Station was built in 1903. Designated heritage building now the Robert M. Nichol Library; turrets on each end, centre tower

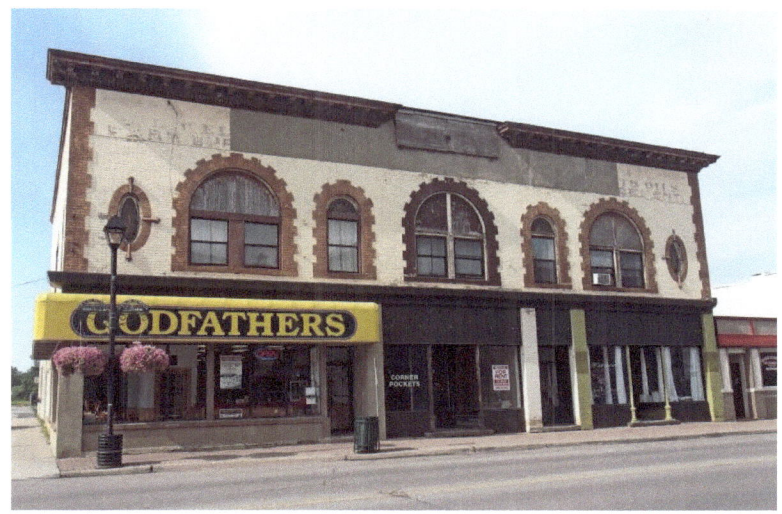

Petrolia Line – dentil moulding, quoining

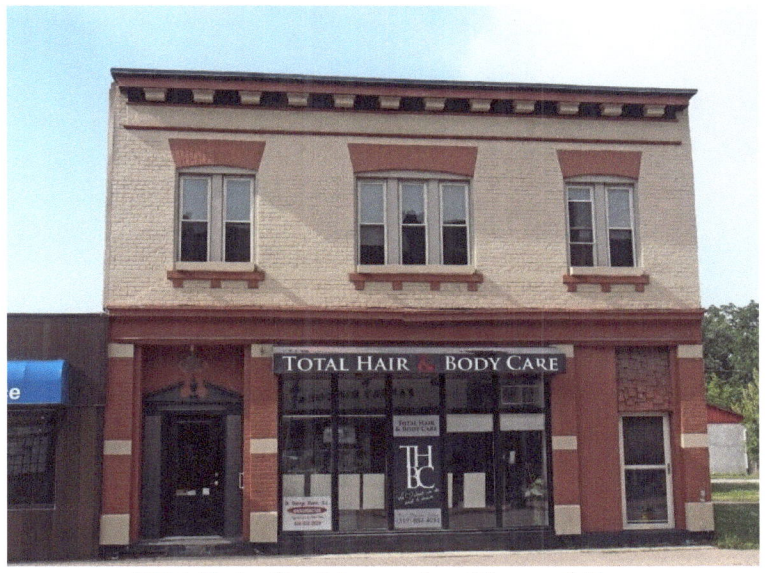

4214 Petrolia Line – dentil moulding

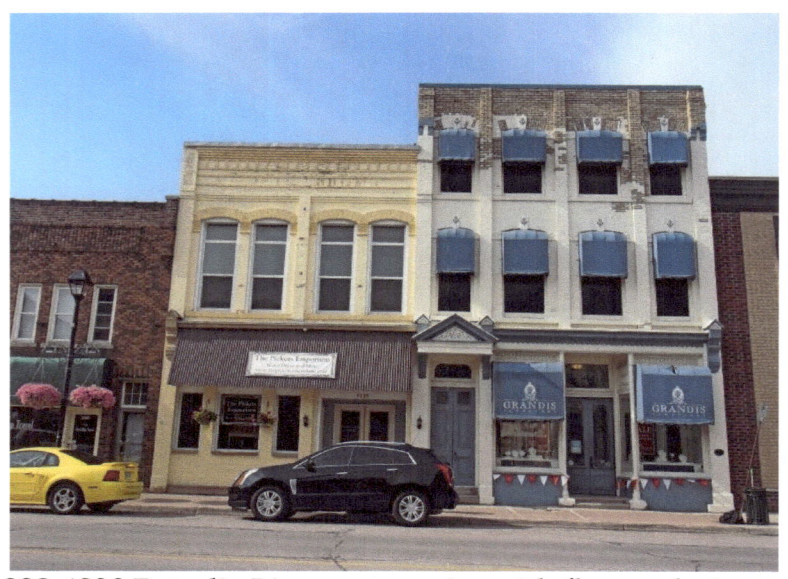

4228-4230 Petrolia Line – voussoirs with flower design on keystones, pediment above door

4245 Petrolia Line – 1869 – Little Red Bank – Gothic Revival

4249 Petrolia Line – Gothic Revival, finial on gable

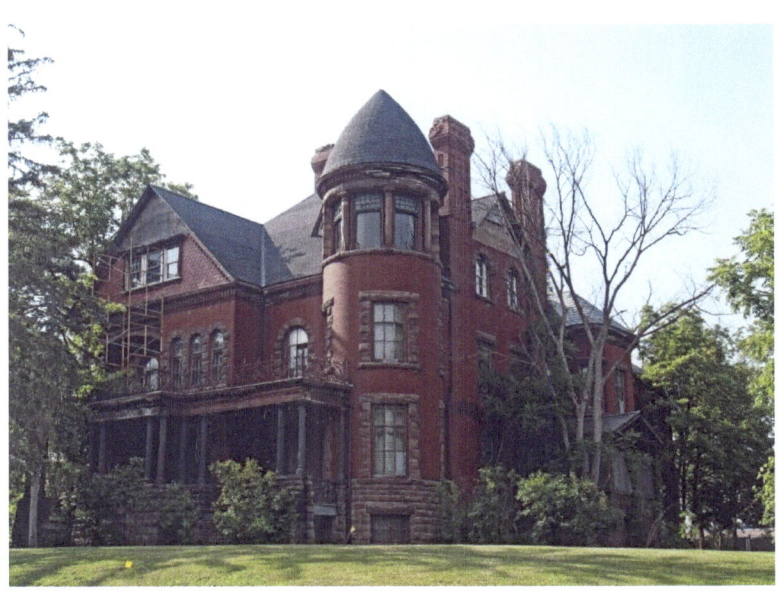

Petrolia Line – Romanesque, three-storey turret, decorative iron railing on second floor balcony

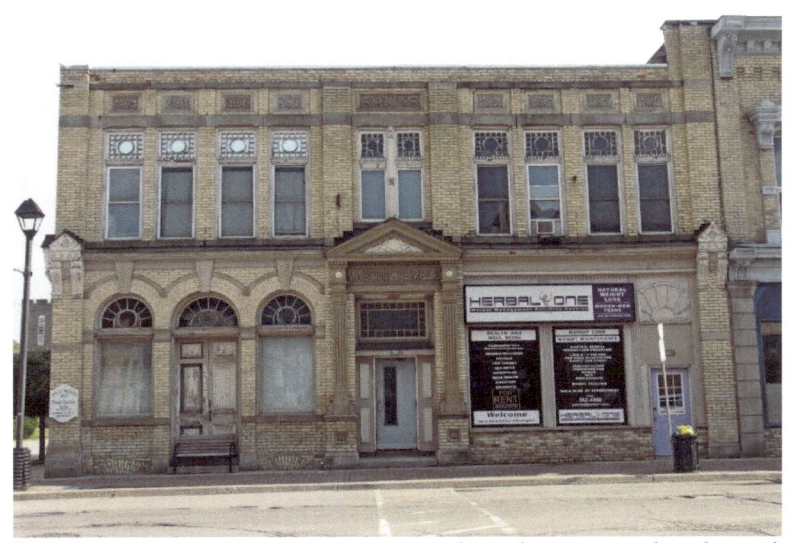

4239 Petrolia Line – Masonic Temple – decorative brickwork, pilasters, Romanesque style voussoirs with keystones, entrance with pillars and pediment with decorated tympanum

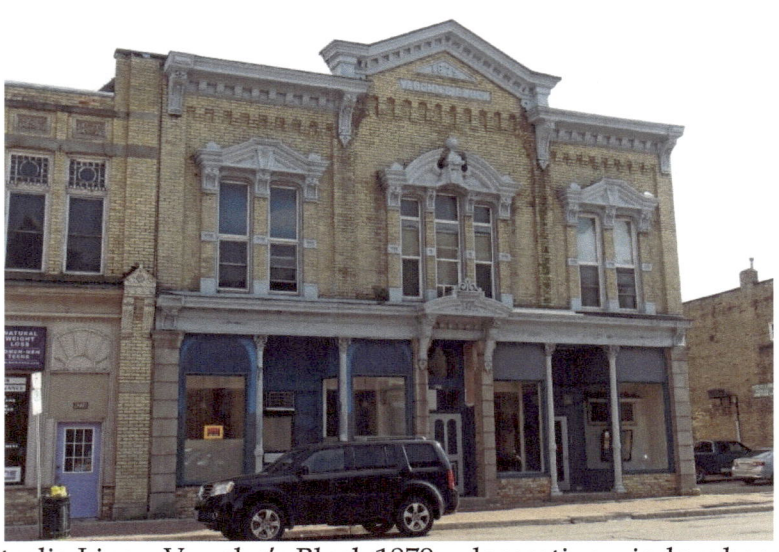

Petrolia Line – Vaughn's Block 1879 – decorative window hoods, bevelled dentil moulding, Corinthian capitals on pillars, pilasters, pediments

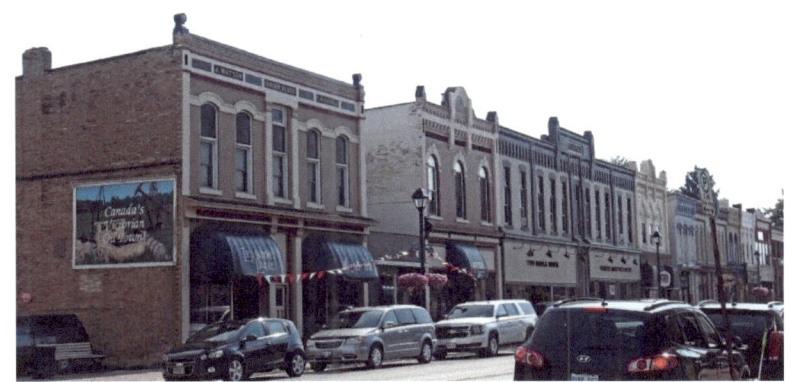

Petrolia Line

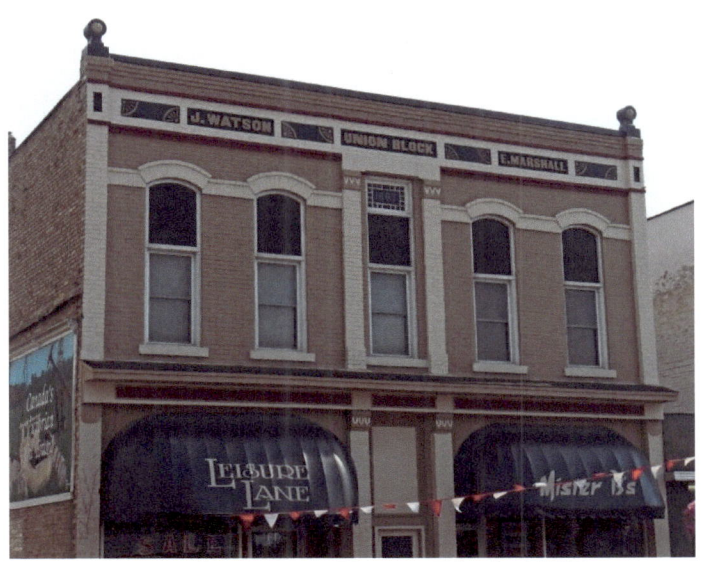

Petrolia Line – Union Block 1887

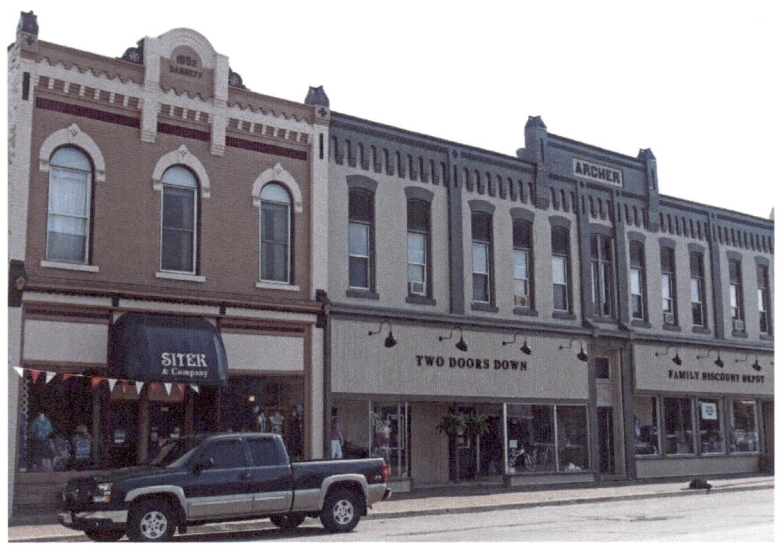
Petrolia Line

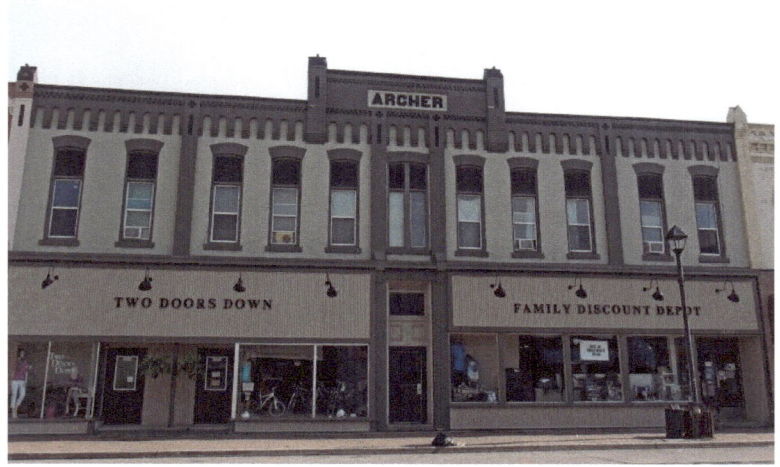
Petrolia Line – Archer Block – saw tooth and bevelled dentil moulding, pilasters

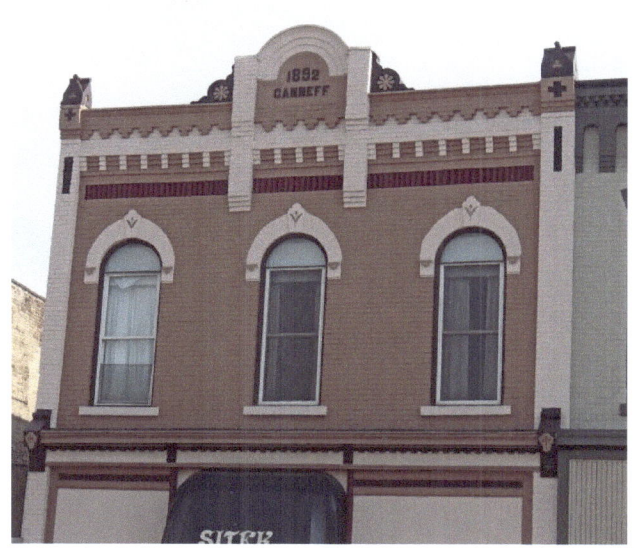

Petrolia Line – Canneff Block 1892 – dentil moulding, voussoirs with keystones with flower motif

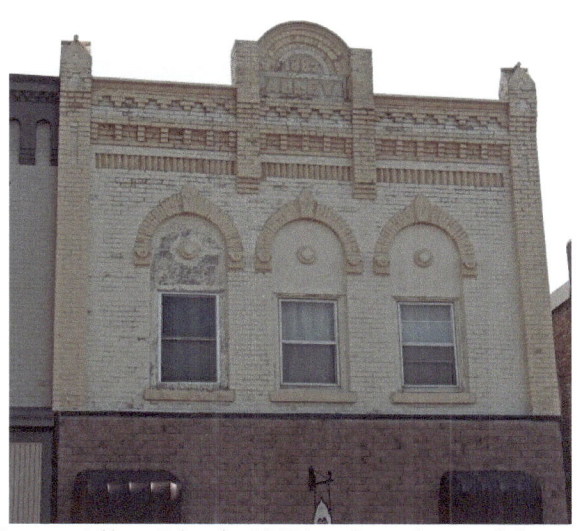

Petrolia Line – Alley Block 1887 – dentil moulding, voussoirs with keystones with flower motif

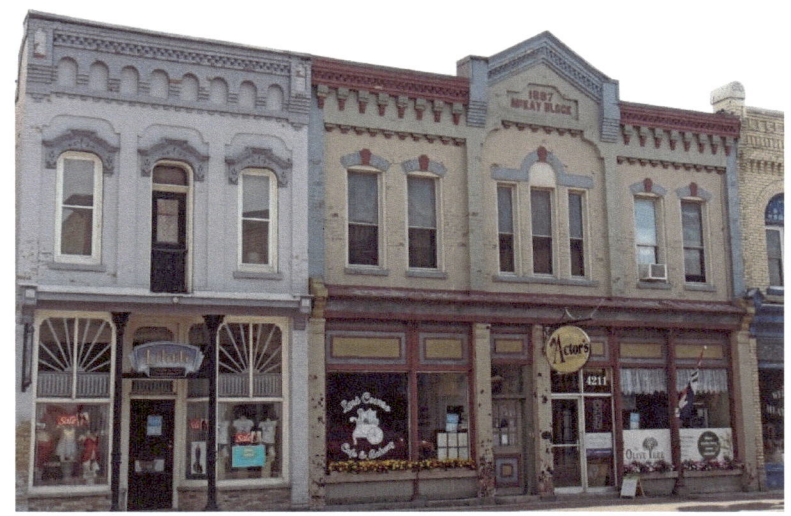

Petrolia Line – McKay Block 1887 – saw tooth and bevelled dentil moulding, pilasters

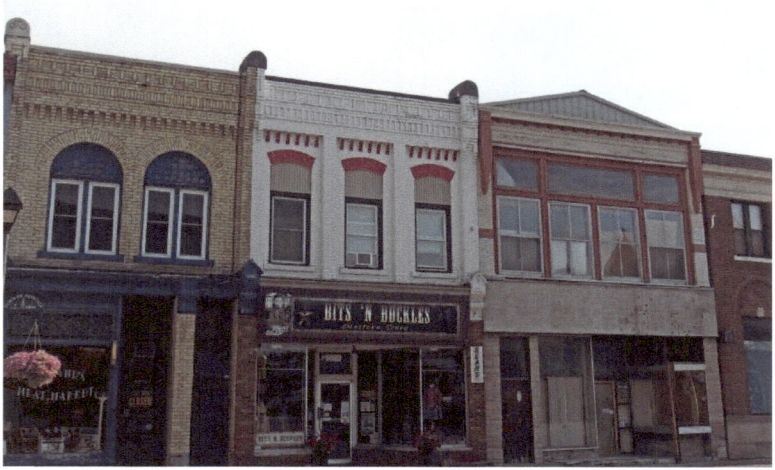

Petrolia Line

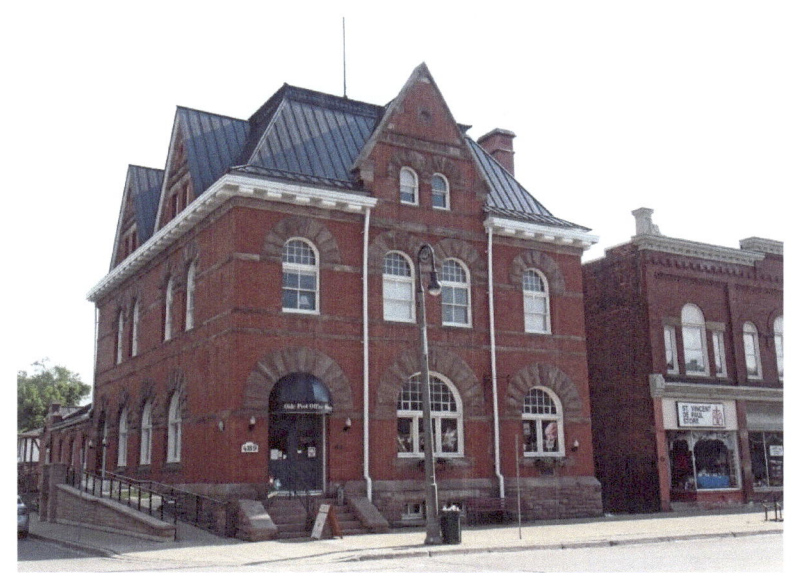

4189 Petrolia Line – Olde Post Office – Romanesque style, banding, Jacobean gable

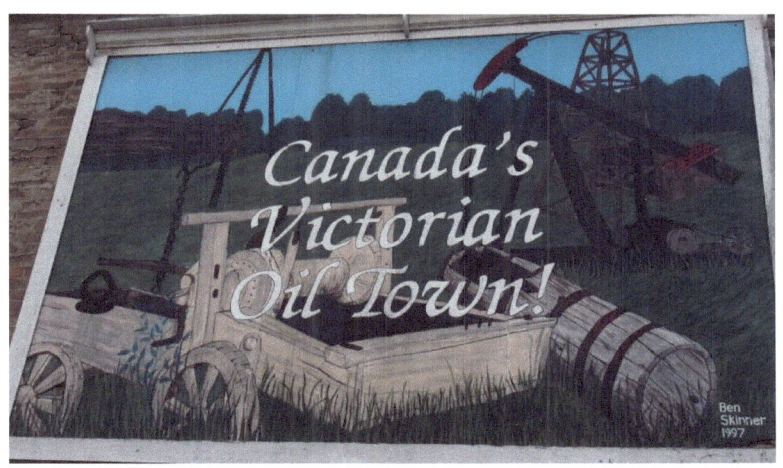

Mural

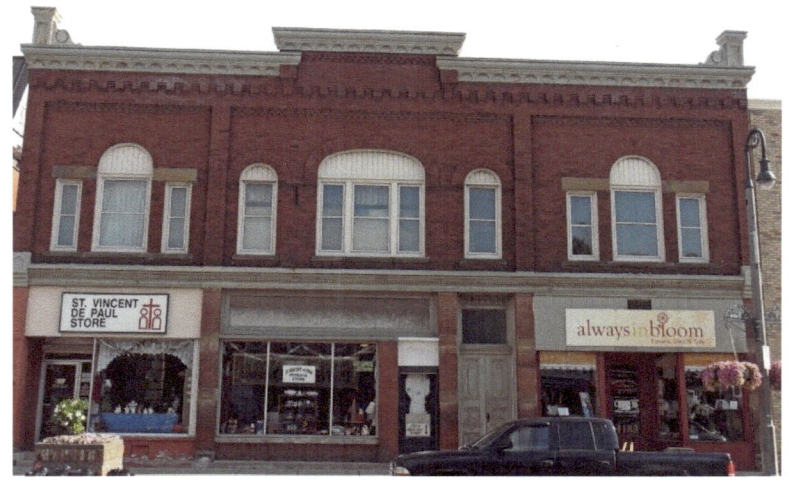
Petrolia Line – bevelled dentil moulding

Petrolia Line – decorative cornice, pilasters,
saw tooth dentil moulding

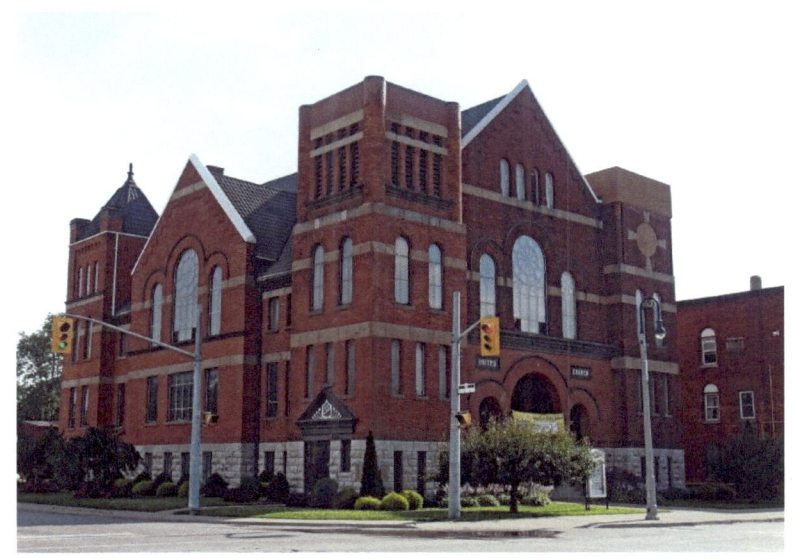

Petrolia Line - United Church – erected 1899 – Romanesque style, rose windows, banding, dentil moulding

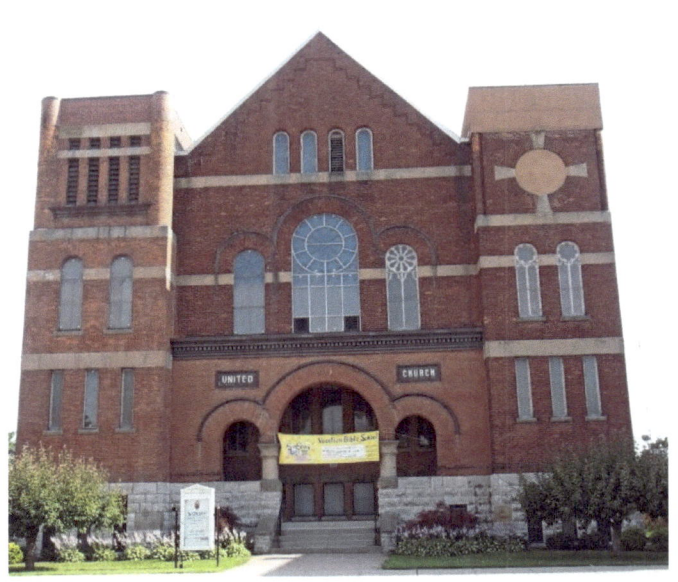

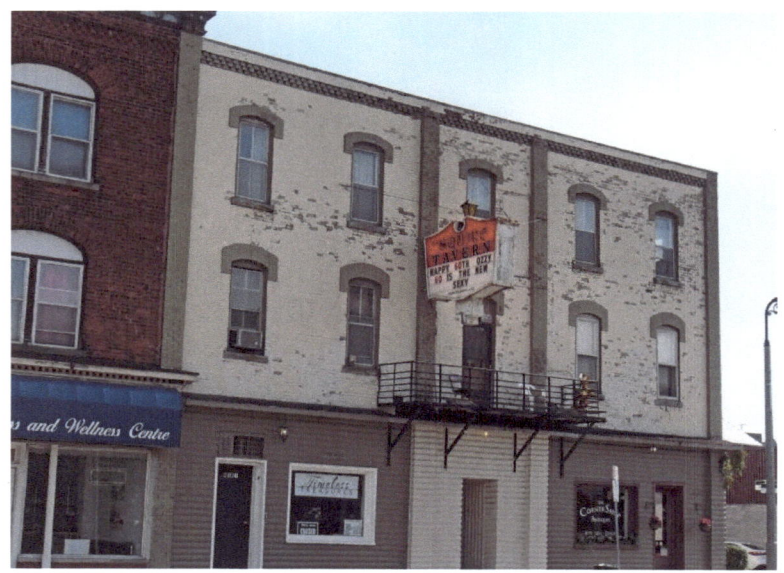
Petrolia Line - pilasters, saw tooth dentil moulding

Petrolia Line – Squire Tavern – voussoirs, dentil moulding

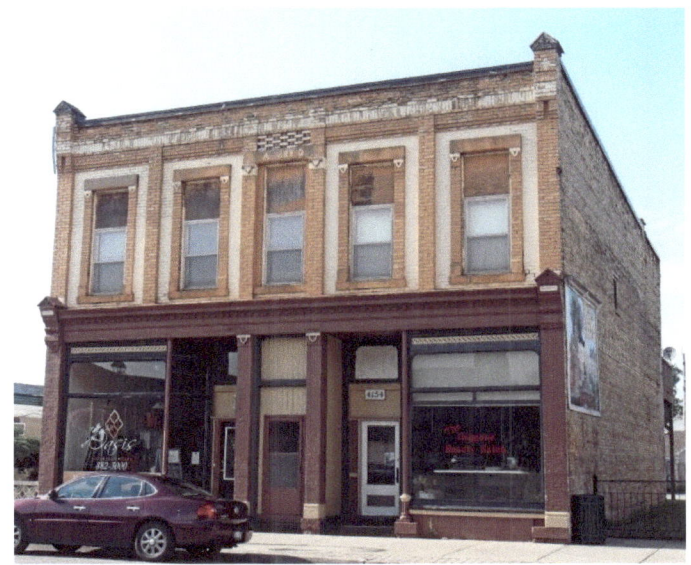

4154 Petrolia Line - pilasters

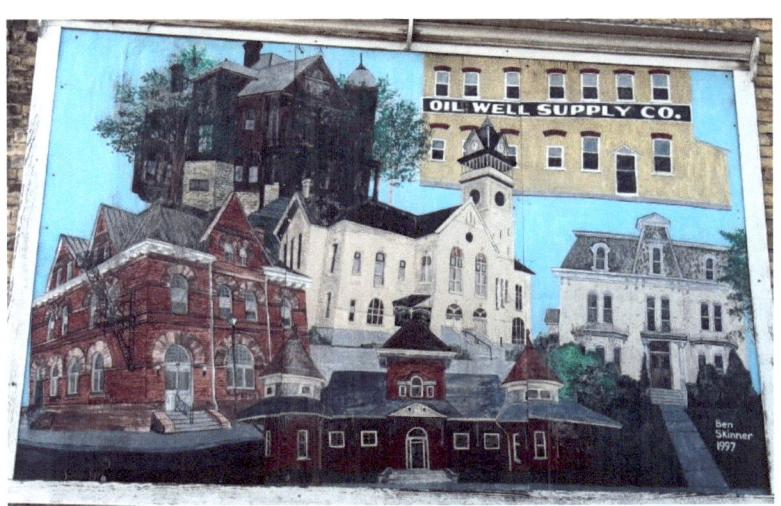

Mural

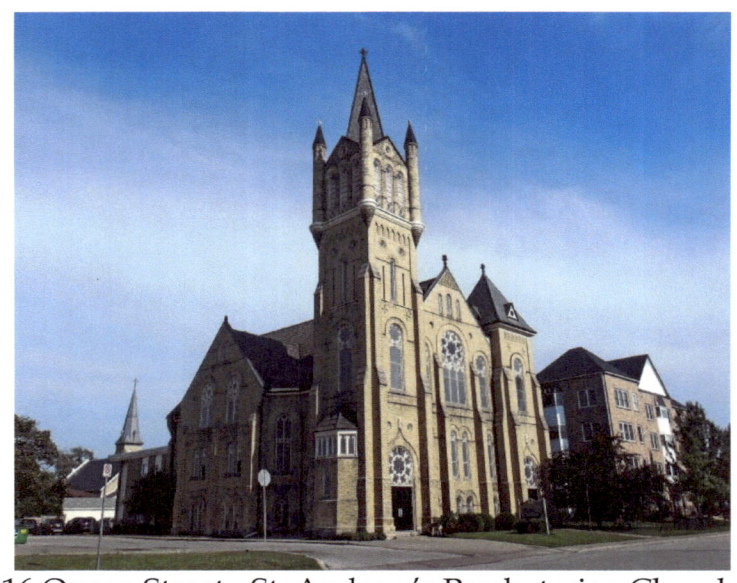

416 Queen Street - St. Andrew's Presbyterian Church – Romanesque style, finials on tower, rose windows, buttresses

420 Queen Street – 2½-storey frontispiece

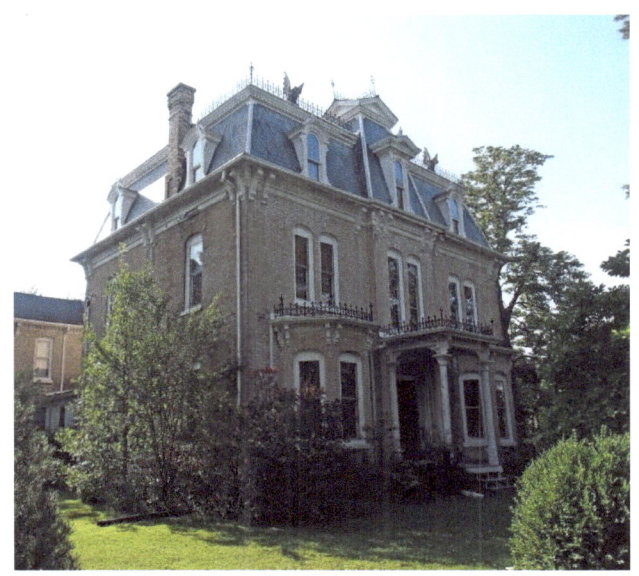

Queen Street – heritage building – Second Empire style, mansard roof, window hoods, iron cresting, cornice brackets, pillared entrance, bay windows

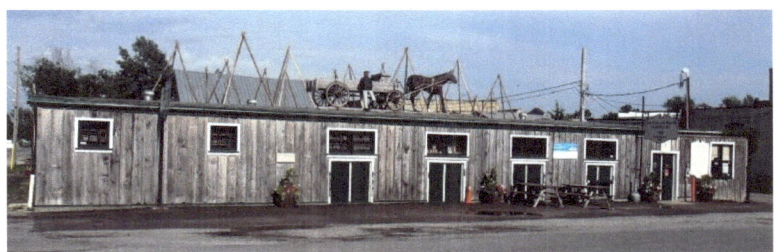

Van Tuyl and Fairbank Hardware established 1865 - where they still thread pipe, cut steel, and sell gumboots - the oldest independent hardware store in Ontario

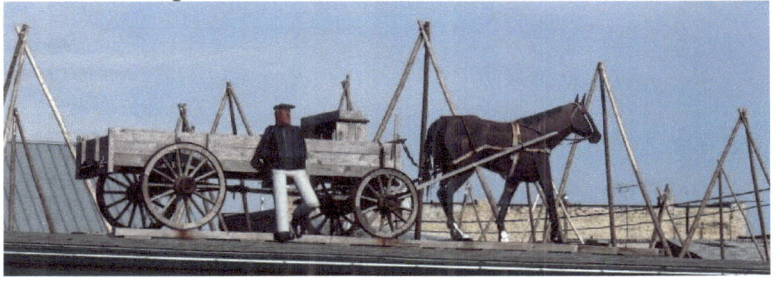

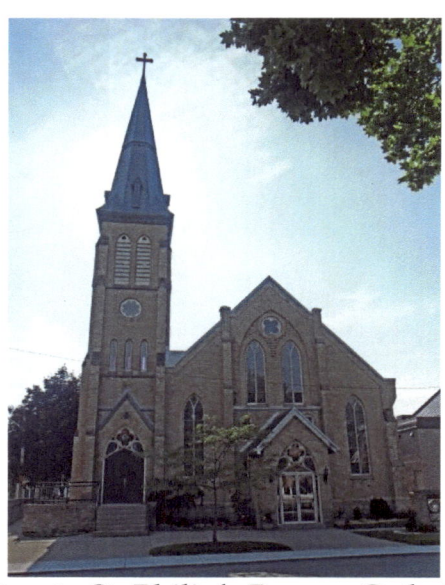

415 King Street - St. Philip's Roman Catholic Church, buttresses, rose windows, lancet windows

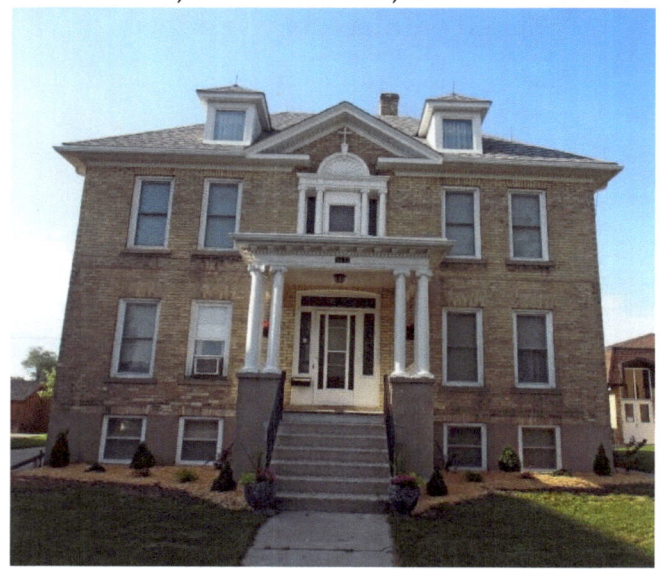

4142 Queen Street – manse for St. Philip's Church – Italianate, hipped roof, dormers, pillared entrance with Ionic capitals, dentil moulding, sidelights and transom window

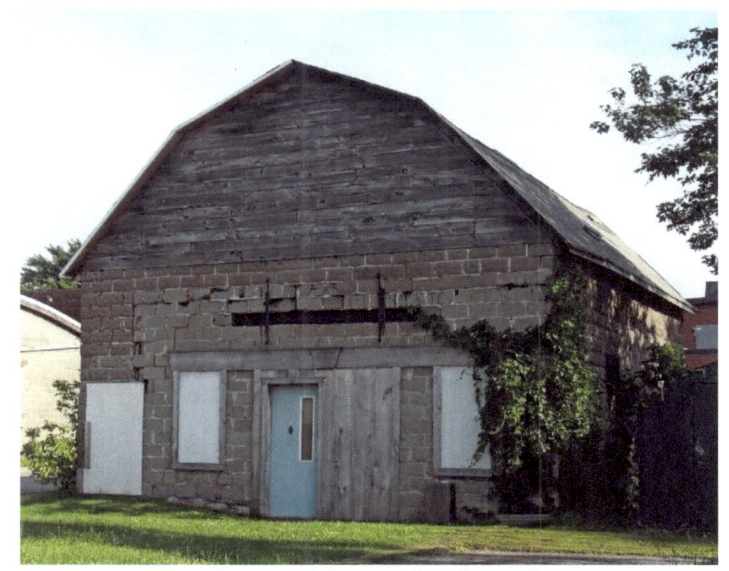

Barn with gambrel roof

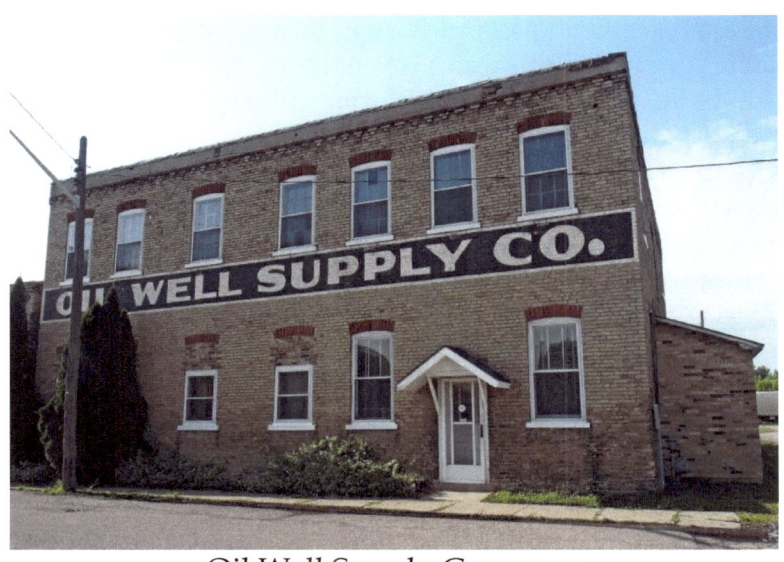

Oil Well Supply Company

 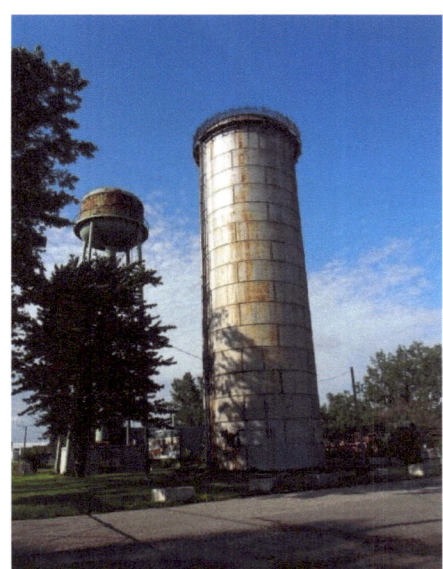

Standpipe water tower

Contaminated wells and creeks caused outbreaks of diphtheria, typhoid and scarlet fever in the crowded shanty town. A reliable supply of clean water was needed. In 1896 funds were raised to build a pipeline of twenty-four miles to Lake Huron, and a water distribution system throughout the town.

Petrolia's new water distribution system featured a wrought iron tower holding 257,700 gallons and measuring twenty-five feet in diameter and eighty-five feet in height. The metal plates, set with blacksmith welds and red hot rivets, graduated in thickness from the top to bottom where water pressure would be greatest. Good water pressure was critical for fighting fires in a highly flammable town.

The water system was completed in 1897 and as well as the standpipe water tower, it included a steam-powered pump house built on the shore of Lake Huron, and one hundred fire hydrants installed throughout the town. At the time of construction, town council could not afford a roof for the standpipe. An ornamental iron balcony reached by a ladder was built for the top.

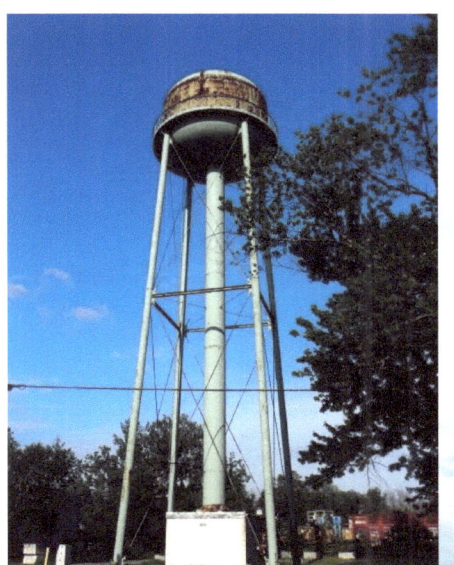 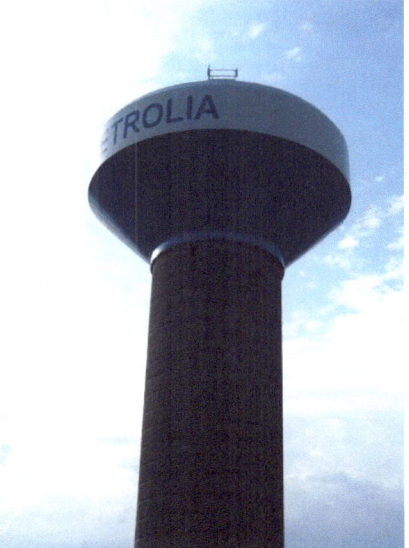

Old water tower New Water Tower

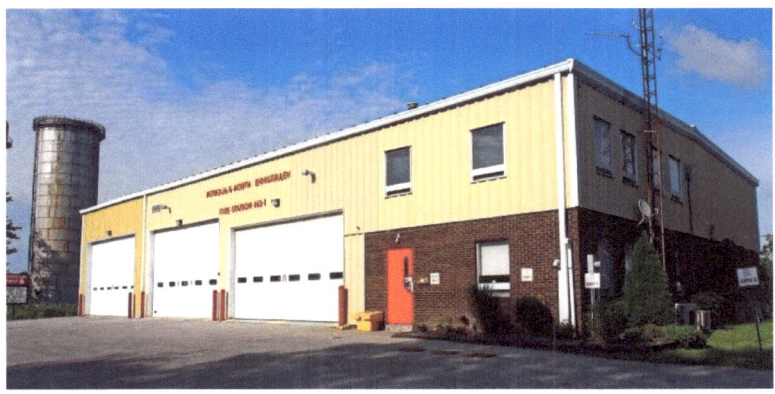

Fire Station

Architectural Terms

Banding: Different materials, colours or textures used in horizontal bands along a wall. Example: 4189 Petrolia Line, Page 29	
Bay Window: A window that projects out from a wall, in a semicircular, rectangular, or polygonal design. Used frequently in Gothic and Victorian designs. Example: Warren Avenue, Page 10	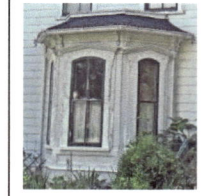
Brackets: a decorative or weight-bearing structural element which forms a right angle with one side against a wall and the other under a projecting surface such as an eave or roof. Example: Queen Street, Page 34	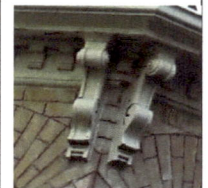
Buttress: a masonry structure built against or projecting from a wall which serves to support or reinforce the wall. In Canadian architecture, they are sometimes used for decoration. Example: 416 Queen Street, Page 34	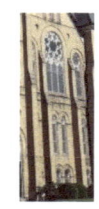

Capital: The uppermost finish or decoration on a column. An Ionic column has a small base, a thin elegant shaft, and a capital composed of volutes which are carved whirls or twists that take the form of a scroll. Example: 4142 Queen Street, Page 36 A Corinthian column is characterized by a rounded capital decorated with acanthus leaves and a square abacus (the uppermost portion of a capital directly below the entablature) on tall slender columns. Example: Vaughn's Block, Petrolia Line, Page 24	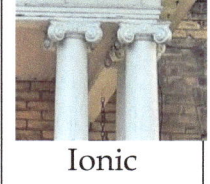 Ionic 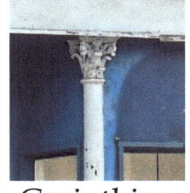 Corinthian
Cornice: originally the wooden overhang of the roof. With the use of stone, brick, iron and steel, the cornice is any projecting shelf at the top of a ceiling or roof. They can be very decorative. Example: Queen Street, Page 35	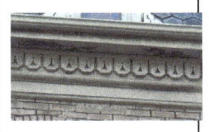
Dentil Moulding: an even series of rectangles used as ornamental decoration in cornices. Example: Petrolia Line, Page 24	
Dormer: (French for "sleep") a gable end window that pierces through the plane of a sloping roof surface to create usable space in the top floor or attic of a building by adding headroom. Example: Emmaline Street, Page 17	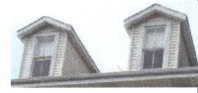
Entrance: The entrance encompasses the doorway and the inner vestibule or, in residential architecture, the covered porch. Example: Queen Street, Page 35	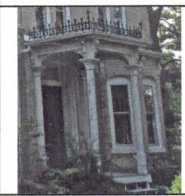

Gable: the triangular portion of a wall between the edges of a sloping roof. **Jacobean Gable:** the gable extends above the roofline. Example: 4189 Petrolia Line, Page 29	
Gambrel Roof: a symmetrical two-sided roof with two slopes on each side; the upper slope is positioned at a shallow angle, while the lower slope is steep. It is similar to a mansard roof, but a gambrel has vertical gable ends instead of being hipped at the four corners of the building. Example: barn, Page 37	
Hipped Roof: a roof where all sides slope downwards to the walls with no gables. Example: #430, Page 17	
Iron Cresting: A decorative ornament along the top of a roof. Iron cresting was popular in the Baroque era and also in Italianate, Victorian, Second Empire and Queen Anne styles of architecture. Example: Queen Street, Page 34	
Keystones and Voussoirs: a voussoir is a wedge-shaped element used in building an arch. A keystone is the central stone that locks all the stones into position, allowing the arch to bear weight. A keystone is often enlarged and embellished. Example: 411 Greenfield Street, Page 18	
Lancet Window: a tall, narrow window with a pointed arch at its top. Example: 415 King Street, Page 36	

Mansard Roof: This style was popularized by Francois Mansart (1598-1666), an accomplished architect of the French Baroque period and especially fashionable during the Second French Empire (1852-1870). This roof is almost flat on the top section, with two slopes on each of its sides with the lower slope at a steeper angle than the upper and having dormer windows. Example: Queen Street, Page 34	
Pediment: a triangular section above the horizontal structure (entablature), typically supported by columns. The inside of the triangle is called the tympanum. Example: 4239 Petrolia Line, Page 24	
Pilaster: a slightly projecting column built into or applied to the face of a wall for additional structural support. Example: 4239 Petrolia Line, Page 24	
Quoin: masonry blocks at the corner of a wall, often a decorative feature, usually larger or of a different colour than the rest of the wall. Example: #460, Page 17	
Rose Window: a circular window with ornamental tracery radiating from the centre. Example: 416 Queen Street, Page 34	

Sidelight: a window, usually with a vertical emphasis, that flanks a door, and is often used to emphasize the importance of a primary entrance. **Transom Window:** the light above the doorway, also called a fanlight. Example: 4142 Queen Street, Page 36	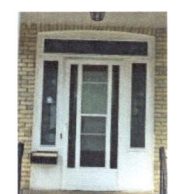
Turret: a small tower that projects from the wall of a building. Example: 4200 Petrolia Line, Page 20	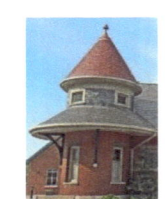
Verge board and Finial: also called bargeboards – hang from the projecting end of a roof and are often elaborately carved and ornamented. **Finial:** ornament added to the top of a gable, pinnacle, canopy or spire – a Gothic element. Example: 429 Ella Street, Page 11	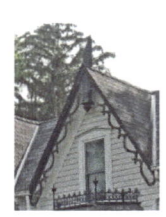
Window Hood: A **hood** is the piece found above window openings, usually of an ornate design, and covers the top third of the opening. Hoods are commonly placed above arched or curved openings on both windows and doors. Example: Queen Street, Page 24	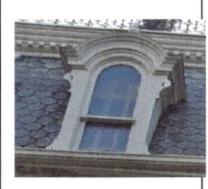

Building Styles

Gothic Revival, 1830-1890 – These decorative buildings have sharply-pitched gables with highly detailed verge boards, pointed-arch window openings, and dichromatic brickwork. It is a common style in Ontario. Example: 429 Ella Street, Page 11	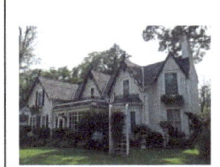
Italianate, 1850-1900 – It has wide-bracketed eaves, belvederes, wrap-around verandahs. Example: 416 Warren Avenue, Page 7	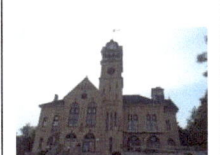
Queen Anne, 1885-1900 – This style is distinguished by an irregular outline featuring a combination of an offset tower, broad gables, projecting two-storey bays, verandahs, multi-sloped roofs, and tall, decorative chimneys. A mixture of brick and wood is common. Windows often have one large single-paned bottom sash and small panes in the upper sash. Example: 411 Greenfield Street, Page 18	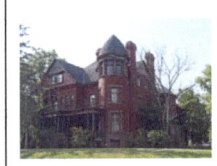
Romanesque Revival, 1880-1910 – This style hearkens back to medieval architecture of the 11th and 12th centuries with a heavy appearance, blocky towers and rounded arches. Example: Petrolia Line, Page 23	

Second Empire, 1860-1880 – The mansard roof is the most noteworthy feature of this style and is evidence of the French origins. Projecting central towers and one or two-storey bays can also be present. Example: Queen Street, Page 34	
Tudor Revival – exposed timbers with stucco infill, multi-paned windows. Example: 4247 Emma Street, Page 14	
Vernacular/Traditional Mode 1638 - 1950 Influenced but not defined by a particular style, vernacular buildings are made from easily available materials and exhibit local design characteristics. Example: 424 Warren Avenue, Page 10	
Victorian - In Ontario, a Victorian style building can be seen as any building built between 1840 and 1900 that doesn't fit into any of the other categories. It encompasses a large group of buildings constructed in brick, stone, and timber, using an eclectic mixture of Classical and Gothic motifs. Example: 4200 Petrolia Line, Page 20	

www.ingramcontent.com/pod-product-compliance
Lightning Source LLC
Chambersburg PA
CBHW040925180526
45159CB00002BA/612